ART & SOUL
CO-CREATION AND SUSTAINABILITY

JOHN MIX

© 2024 by John H. Mix

All rights reserved

This book or any portion thereof may not be
reproduced or used in any manner whatsoever
without the express written permission of the publisher,
except for the use of brief quotations in a book review.

Printed in the United States of America

First Printing 2024

ISBN 979 8 218 35259 2

John Mix Press

www.johnhmix.com

Cover Art by John H. Mix

Graphic Design by Chad Becker

To my parents Clara and John for my roots in the bountiful land; my midwives in art Sister Blanche Gallagher, BVM, and muralist David Burnside; Rev. Matthew Fox for bringing the deep well of juicy creation spirituality to light and life in our pivotal time; my wives past and present for their love and support and my family, children and grandchildren for whom my gratitude will never be suffcient.

ART AND SOUL: Co-Creation and Sustainability

Contents

Introduction	7
Chapter 1. From Chaos to Cosmos	11
Chapter 2. Calling	19
Chapter 3. Our Soul's Desire	29
Chapter 4. Art As Way	41
Chapter 5. Resistance and Release	53
Chapter 6. What's Mything (in My Life)?	65
Chapter 7. Distractions	75
Chapter 8. Co-Creation and Sustainability	83

Introduction

> "Creativity is the longest standing habit
> of the universe." (Matthew Fox)

Creativity is our human birthright. How that gets lived out is our story and the story of civilization since the beginning. The bad news is we haven't been the best managers of that creativity. Just as we are capable of great beauty and wonder, we have brought about much tragedy and suffering. The fact is people function at the level of consciousness they have at the time, and this has gotten us to where we are today in all its complexity. I am writing as a landscape and portrait artist in oil and pastel and also an expressive arts teacher, both a culmination of my lifetime fascination with art, spirituality, consciousness and social justice.

Creativity is in our nature and how it manifests itself is our life story. It is how we got here in the first place and how we are sustained day by day. Human nature unfolded and here we are. Can you imagine a world without music, dance, visual images, books, or tools? One of the most pernicious lies afoot today is the notion that only some people are creative. Show me a drug addict out of money and I'll show you someone who will lie, steal, abuse, or kill someone in order

to get the next fix. That's creativity down the dark path. As human beings we co-create our lives with our health, skills, knowledge and faith and it can be life-giving or destructive to ourselves or others. I'm not saying the path is simple or easy. I am saying it is universal and has never been more urgent for us to reckon with as the only species with any choice about how it is used. I'll expand more on that later.

As an artist for over 30 years I am writing this because you matter and the earth matters. We want the best for our life and for our loved ones, and we are the only ones who can make the healthy choices toward that end. Our imaginations are being challenged today to find the most sustainable way to co-exist with humanity and all the species that live here. We are orbiting the only known star that produces vegetables where we live. We are the species entrusted with the imaginative energy to co-create a healthy life and a promising future. If you are experiencing boredom, consider it a message from the universe that your gifts are waiting to be discovered and embraced. You have gifts the world needs. The seed in your imagination contains the DNA of the future you are already co-creating today. The macrocosmic creative process can teach us all about the microcosmic creative process. Let's get started.

Chapter 1.
From Chaos to Cosmos

"We need to see ourselves as integral with this emergent process, as that being in whom the universe reflects on and celebrates itself."
Thomas Berry, The Dream of the Earth

It's important to look at the big picture first. It took the universe almost 14 billion years for us to get here, obviously a stretch for anyone's imagination. Astrophysicist Neal DeGrasse Tyson offers the image of evolution as a football field of 100 yards. All of human history is the width of a blade of grass at the end zone. Feeling insignificant is easy, given the enormity of the planet, the universe, and the forces that have supported life up to now. The pictures of deep space from the Webb telescope are stunning. I can almost hear you saying, "If it was your aim to encourage my creative choices, I feel even less creative now." I get it. But it is also possible to get a precious glimpse of the unique blessing that you and I are.

Evolution never stops. In the grand scheme of things a human life is a tiny blip on the screen of existence. How much difference can one life make in the big story of the planet? There is no need to quantify

it even if we could, but we know teachers, sages, wisdom figures over the ages have stepped into their potential and brought us priceless gifts of knowledge, insight, and wisdom about what life is and what is important. No need to make comparisons. In the realm of people, comparison is suffering. We can be thankful and blessed by their co-creative work. You only have to be you. Everyone else is taken. We would not be who we are today without our parents, family, teachers, mentors, and friends who have each given of themselves and thereby contributed to our evolution as individuals. Personally, my experiences in the natural world growing up in Minnesota, my travels, work experiences all had a role in shaping my imagination and what is of ultimate value in my life. This is why I refer to co-creation rather than simply creation. We live in a sea of influences inside and outside of our bodies. Our health, acquired habits, faith, values, environment, relationships and much more provide a deep matrix of co-creation. If the universe tells us anything, it is about our interconnectedness, all the way up and all the way down. It is impossible to be truly alone. We feel alone and possibly insignificant at times, but that is viewing the small narrow picture. Time to reframe.

World renowned agent of human potential Jean Houston refers to "kvetching" as those times when

Chapter 1. From Chaos to Cosmos

we are caught in our small stories of complaints, shortcomings, and disappointments. It's a place of relative powerlessness and "poor me" thinking. If you haven't been there before, raise your hand. You are the only one in the world. Call it search mode. When it becomes a lifestyle it's more than troublesome and annoying. We experience being "stuck" when we believe something that is untrue. There is no reality called "stuck." It is a conversation in our heads. In the larger context of evolution our feeling small, weak or powerless is a school for learning: how did I take on this feeling of being a victim? (More on this in a later chapter). Who did I give my power to? What do I get out of staying in that conversation called "stuck?" We may get some sympathy mileage out of it at times. The key is to connect our little story with the Big Story of the universe. Our kvetching might be a little story of loss, failures, mistakes, or state of mind such as mild depression. In the context of the Big Story nature teaches us that every stage of growth is essential for the next stage. Everyone fails and eventually dies. I don't mean to minimize the gravity of loss, injury, and failures. Every experience has a place in the cosmos. Witness the change of seasons, the dying and being born anew. As I write in the Wisconsin spring season the flowering trees are delightfully aromatic. That stage of gorgeous

flowering gives way to the rather acidic colors of the emerging leaves followed by the full summer glory and the exuberant autumn. As a landscape artist in a Wisconsin summer I could complain about the "tyranny of green." Yet another chance to grow into what's next in my evolution in painting.

So how are we connected to the fundamental forces operating in the universe? For starters, nothing would be here without gravity. It holds us in our somewhat elliptical orbit at 67,000 miles an hour around the sun. Even though scientists can't fully explain this force that permeates the entire universe including you and me, we at least can say it is a force of attraction. What are you attracted to? What are you continually interested in? Curious about? Some of these attractions are fleeting and some persist over time and maybe even for a lifetime. These attractions within are the microcosmic equivalent in us of the macrocosmic force of gravity everywhere.

Another way to get at it is the question: what's always been there in your life? It may be a persistent interest in some subject or activity. Many years ago I met juveniles in prison who had been in countless foster homes. In those cases an absence of stability and consistency was always there. They were fortunate

Chapter 1. From Chaos to Cosmos

if there was no abuse or neglect. Experience shapes one's interests in life in a powerful way too.

I've always been fascinated by the natural world, its power, grandeur, and beauty. I grew up fishing, camping with Boy Scouts, watching birds, climbing trees, discovering sketching and drawing on my own, carving and building things out of wood. I was curious about rocks and what they look like inside. Being the youngest of five siblings, some much older, I had more time on my own to explore and wonder without sibling rivalry and competition. My other main interest was serving others. Mom was a nurse's aide at a hospital and I was her helper at home. I mowed the lawn, shoveled the snow, and changed the storm windows when I was old enough. Between the ages of 11 and 15 I worked on my sister's small dairy farm during the summer. This immersion in the natural world connected me firmly to the wonders of nature and the value of helping family operate a farm. If I had better grades in math and science I might have chosen forestry conservation as my career. I chose to study for the Lutheran ministry and soon met ministers who were also artists. That reawakened my childhood interest in drawing and set the stage for an eventual synthesis of art and ministry as a part-time chaplain in prisons.

ART AND SOUL: Co-Creation and Sustainability

My advice to my kids heading off to college was "follow the fire." The fire of interest, enthusiasm, and curiosity is our personal equivalent of the Big Bang. It all starts with what lights you up. What activities, topics, people, conversations, issues pull you in and keep you interested? Even if you discover something different down that road (as I did) there is no better place to begin than with the inner truth you know now. When juveniles in prison learned that I was an artist they said, "Can you draw me?" I was happy to do a pencil sketch and give it to them. Some asked if I could teach them to draw. I said, "It depends on how interested you are." Only enduring interest and curiosity will get you through the inevitable disappointments and setbacks that are standard in any path of learning. Great paintings often start with a sketch and even after they are finished we don't see what was painted out to arrive at the result we see now. We also don't see what challenges the artist encountered on the way: death of a spouse, rejection by galleries, illness, etc. What survives the peer review gets published. All the failed experiments helped the inventor finally bring something of value to the world. Most of us found work and situations that didn't suit us before we found the work we preferred. Nothing is truly "wasted" in life if we learn from it. Whenever we failed, hopefully we did not

Chapter 1. From Chaos to Cosmos

fail to learn the lesson. Swami Beyondananda (Steve Bhaerman) said, "Sometimes the universe will create a farce-field just for our benefit, and we remember that life is a situation comedy and we are just having an episode." It always helps to have a sense of humor, but especially when plan A does not work out. In the cosmic Big Picture failure is a step to get to the next level of evolution. It's the same for you and me. Leonard Cohen sang, "There is a crack in everything, that's how the light gets in."

Questions: Who or what have been your best teachers?

What were you most curious about as a child? What did you enjoy?

Who or what were some of the biggest influences in your life?

Chapter 2. Calling

"The place God calls you to is the place where
your deep gladness and the world's hunger meet."
(Frederick Buechner)

This definition of vocation struck a deep chord within me as I wrestled with guilt about the possibility of leaving parish ministry in my mid-30s to pursue art. My paraphrase is: You love to do it and the world needs to have it done. I had just experienced drawing classes for the first time and realized I had come home to something very old within me. It is not wise to ignore or downplay our deep gladness or the world's need. Various levels of depression were a signal that I needed to ask a bigger question: "Am I doing what I love and loving what I'm doing?" Unfortunately this is not a lived reality for many people. According to a Gallup poll in 2022, 85 percent of people do not love what they do for a living. Some hate it, some tolerate it in order to support themselves and their family. This comes at a cost for everyone. The vulnerability to harmful levels of stress, addiction, depression and eating disorders is very high. Be alert to interrupted sleep patterns. Ten years as a Lutheran minister is what I call my "first life." I enjoyed pastoral care and counseling but struggled with the organizational/administrative part. My wife could see the career

ART AND SOUL: Co-Creation and Sustainability

mismatch sooner than I could. In my last year I took my first fine art class in drawing and felt the joy that I knew in drawing as a kid. I engaged in career counseling and later left parish ministry to work as an apprentice with a mural artist in the same suburb where we were raising our family. I accepted the challenge of co-creating the financial support for our family that this decision entailed. Enter house painting as a backup.

How do we balance the conviction that we love to do certain things or work in certain ways with our responsibility for family and community? Working with people or with our hands is often the artificial choice. We are happiest when what we do for a living comes from a joyful heart, and it supports us and those we love. Ninety-five percent of artists have a proverbial "day job" to support the dream. When we don't enjoy our daily work, the creative challenge is choosing the "frame" we put around it. Is it a burden or a learning experience? Is it motivation to discover what I really love, what is really satisfying to my soul, or am I a loser, a victim of my upbringing and bad luck? "We live in a description of reality," Jean Houston once said in a workshop I attended. To frame our lives from within a victim mindset is to literally send the power for change away from us. Houston's teaching did not sink in when I first heard it and wrote it down.

Chapter 2. Calling

It leaped off the page when I was depressed and ready to see it afresh. Every discipline you can think of whether science, philosophy, religion, mathematics or literature, operates in a description of reality from that perspective. Every one of them has evolved and changed over time. Isaac Newton compared the smallest bits of matter to the equivalent of billiard balls bumping into each other. Now we know the flow of energy and matter is constant, always in flux. The point is that descriptions change. Our descriptions of our "reality" can change too with the kind of frame we put around our life circumstances. Sometimes we find the kind of work we love after doing work that doesn't suit us. Seeing the challenge as learning rather than a curse is the difference between power and powerlessness. We are co-creating our reality by listening to our heart's pain and joy and not losing the lesson.

In my early years as an aspiring artist I worked part time as a chaplain in a medium security men's prison. When men were close to finishing their time I asked, "What do you plan to do when you get out?" Get a job. "What kind of job?" I don't know, anything is ok. I was surprised that over all those years they had not come up with a dream to fulfill. Later I realized that a hard life of poverty or abuse can kill dreams. There is only survival and getting by. Making it to the next day

or paycheck is a success. However, anything that dies in the psyche can rise up and be born again like the legendary phoenix. But only after some sober letting go of the pain and loss carried in our bodies and our stories. Science fiction writer Ursala LeGuin wrote, "The creative adult is the child who has survived."

I led expressive art sessions in prison where men used oil pastels and crayons to help them get present to what they were feeling at the time. It was a safe space where no criticism of others was allowed. I often gave them a question as an option to consider like, "What is your earliest memory?" One young man showed me his paper where he drew a stick figure standing next to a rectangle with a jagged line in it. At the bottom he wrote "When my dad broke out all the windows in the house." I said, how old were you? "Six," he said, "I hid with my grandma in a closet while my dad raged." Now, 20 years later, he was in prison for the same alcohol addiction he witnessed with his father. When trauma seizes our imagination, especially at an early age, it can lock up our hopes and dreams and prevent us from living out and expressing our inner beauty. Sophia in the movie The Color Purple said, "I know what it's like to wanna sing and have it beat out of you." Co-creating more freedom hopefully will come in the presence of trauma-informed care and compassionate listening.

Chapter 2. Calling

Another example of the interdependence that is the reality of our universe. We need each other.

It may be common to associate art-making with calm and serene awareness such as painting a flower or making a quilt. Pain, loss, and alienation are also generative experiences that can be channeled and translated into art. It is our human birthright to express in some non-violent way the depths of our heart—both the beauty and the tragedies of life. We co-create with our pain and loss. Country singer Jerry Reed sang "She got the goldmine, I got the shaft." Beethoven composed symphonies even while he was blind. Artemisia Gentileschi was the only daughter of her artist father Orazio in 17th century Italy. Very skilled at painting, she was raped by her tutor as a teenager but continued to create powerful paintings even though she was slighted professionally by the male-dominated culture. British singer Adele won a Grammy award for the song "Someone Like You" after her first relationship broke up. A Zen proverb expresses it this way: "Obstacles do not block the path. They are the path." Wisdom is here in our bodies and in these moments. Life is learning how to listen deeply to our heart's longing for meaning and purpose. Getting beyond the static and distractions enhanced by an increasingly screen-dominated lifestyle can be a first step.

ART AND SOUL: Co-Creation and Sustainability

A turning point for me was when I painted the interior of a newly constructed four bedroom house by myself. I had bid on work for this contractor before but additional requests were made near the end. The final payment for my work did not reflect sufficiently the additional work. I felt so burned out by this experience that I resolved never again to do a job this size by myself. Second, I decided to increase my self-promotion as an artist and sculptor. I needed to ritualize my resolve beginning with burning some symbols of my house painting work where I could be safely alone. Over that fire I made my declaration and my request for guidance. Within six weeks I saw a newspaper article about a church being built in a neighboring suburb. I called the pastor and learned that they were considering proposals for a large risen Christ sculpture. I submitted sketches and was chosen for the largest commission I've ever done—a 14 ft mixed media risen Christ placed in front of a cross-shaped window high above the sanctuary floor. Breakthroughs can be co-created out of heartache and pain, anger and disillusionment. Whatever is not working in our life is an invitation to go deeper. Is it the work or relationship, or is it the way I do them? It can be both, of course. Any time we ask, "Is this all there is?" The answer is no. Nothing is only what it appears to be. It is always more. Illness can be our

Chapter 2. Calling

body's way to get neglected rest, or a change in diet and exercise. Depression helped motivate me to look more deeply at my calling as a minister (it helped that I met other ministers who were artists). The fact that over 4,000 books in the United States have the word "happiness" in the title suggests we are continually searching for it and coming up short.

There is both message and meaning in life's ups and downs. We often co-create our purpose and calling out of wounds and losses. The archetype of the artist is the story of the Hephaestus myth. Born of Zeus and Hera, Hephaestus is rejected and abandoned for some perceived fault or flaw. He is the god of the forge who spends his life making beauty with his hands as the only god on Mt. Olympus who worked. The others got someone else to do it for them. Reading this story for the first time in Jean Shinoda Bolen's work, Gods in Everyman, I felt a profound connection to the larger, deeper story of my life. My psychological makeup, values and priorities were echoed in this story of the god of the forge. I felt so deeply seen for who I am at a profound level. As the youngest of five siblings with an age spread of 20 years, my experience was more that of an only child. One of the gifts was to have plenty of solo time to create and build things with my hands. The challenge was plenty of time to have self-doubts and feel left behind. If you felt sibling rivalry

ART AND SOUL: Co-Creation and Sustainability

growing up, it may have toughened you up a bit for life ahead. Life gave me friends for that. The poster may be a bit trite but "no mud, no lotus" seems to be true. We wound ourselves with our negative beliefs and are wounded by others in myriad ways. Often our life purpose or calling emerges in response to those wounds. Poet Brian Wurmser wrote, "What would happen if we heeded the admonitions of beauty?" I now summarize my life's calling this way: "To celebrate the beauty and mystery of life" through my family and relationships, painting and expressive art workshops, writing, social and environmental justice advocacy, and leisure.

Questions: What would you do if you could do anything in the universe?

When did you feel "stuck?" Who or what helped you get a breakthrough?

What is the wound or loss that you don't think you can recover from?

Chapter 3. Our Soul's Desire

"Desire, passion, beauty, all signs of soul."
Thomas Moore

"When you take one step toward your soul, soul takes two steps toward you." Robert Bly, poet

Let the beauty of what you love be what you do.
Rumi, 13th century poet

"Soul is the largest conversation you are capable of having with the world." Bill Plotkin, Wild Mind

Is the life you are living too small for your soul's desire? Boredom is our body's way of telling us we are not using our gifts. They do not sit quietly within. They protest in the form of boredom and sometimes depression. Press the remote for another channel. Binge watch TV and see if it subsides. Folk singer John Prine sang "I think my heart is getting bored with my mind." The horrific levels of addiction and obesity in America hold a mirror to our empty lifestyles that cry out for depth and meaning. There are different ways of seeing our hunger. What are we really hungry for? Eating a bag of chips will not soothe the feeling of living another day without meaning and purpose. Neither will winning the lottery. That definition of "rich" or "abundant" does not have a

ART AND SOUL: Co-Creation and Sustainability

great track record. What is essential is invisible to the eye. "Soul is that autonomous energy that courses through the material guises of the world—you, me, nature, dreams, etc. When inner and outer engage, unite, we experience this as meaning. Thus soul exists outside us, but something central to our nature is similar in nature and desires to connect. Thus soul solicits us even as we seek it." (James Hollis, Finding Meaning in the Second Half of Life, p.191) What you are looking for is looking for you. Only your heart will tell you if the connection is right. When you hear the words "You're hired," your search is partially over, at least for a while. My son worked as a bartender while attending college and for a of couple years afterwards because the national economy slid downward after graduation. It was a time to reevaluate his career path. When he met a physical therapist and heard about her work, something lit up inside. He enrolled in anatomy courses and aced them, which led to physical therapy education and his current success in the field. How do we know when we are on the right path? Excitement, curiosity, desire ignite our imagination within and power us through the challenges ahead. We follow our inner "gravity" (attraction) to what lights us up. We avoid places, people, and activities that do not hold our interest very long. Likewise when we experience the

Chapter 3. Our Soul's Desire

restlessness, ennui, and boredom in our work we sense there must be something more to life that we are missing. Seeking out therapy for depression as a parish minister was a call for course correction. The first was that the way I was working was not fulfilling enough (my skills were not a sufficient match for the particular needs of the parish). Second, I had gifts within that were not being put to use. It helps to realize we are evolving beings, spiritual beings living a human life. We are not the same person at 40 or 60 that we were at 20. Give yourself credit for making it this far, for asking bigger questions. Most of us do the best we can with the light we have at the time. The pathos, yearning and restlessness are not meaningless. They are calling for a bigger picture point of view, a "zooming out" for better perspective.

Cosmologist Brian Swimme gave me that in his book The Universe is a Green Dragon: A Cosmic Creation Story. Thanks to modern science we are the first generations to know the evolutionary story of the universe. What began 13.8 billion years ago is still unfolding today…including in us. How did the stars come into being? By immense powers of gravity that can be called attraction, hydrogen atoms fuse together to form helium and ignite into magnificent fire. First the Hubble and now the Webb telescopes have given us unprecedented views of this

galactic drama going on 24/7. Brian calls this force of gravitation allurement. This allurement ignites being and creates life. And the same holds true for human beings.

"You do not know what you can do, or who you are in your fullest significance, or what powers are hiding within you. All exists in the emptiness of your potentiality, a realm that cannot be seen or tasted or touched. How will you bring these powers forth? How will you awaken your creativity? By responding to the allurements that beckon to you, by following your passions and interests. Alluring activity draws you into being, just as it drew the star into being. Our life and our powers come forth through our response to allurement." (p. 51)

I felt guilty for leaving a profession that I had prepared for through eight years of education and given ten years of my life to. But I could not deny the exhilaration and joy I felt exploring art. This is the way the universe is made: our attractions (gravity) are where they are and we pay a price for ignoring or denying them. It does not necessarily mean a career change. Our soul is enlarged by taking action on that allurement. Take a class, read a book, talk to someone who is knowledgeable about your interest. Could I have done art as a hobby and stayed in ministry? Yes,

Chapter 3. Our Soul's Desire

if I had enough enjoyment in the tasks and the right skills in relation to the needs of that congregation. Career counseling helped reveal the imbalance and also the level of interest and inner fire for pursuing art fully. The power of allurement was drawing me into joy and aliveness. This is the way the universe works. God calls us into work and can call us out to another path. As it turned out, four years down that road as an artist (with house painting as a backup for cash flow), I discovered prison chaplaincy part time and knew I had found a match alongside my art-making. There is a 5 letter word for the key to success: enjoy! A sense of satisfaction resonates deep within when what you love doing is meeting the needs of those around you.

No one seeks out a dentist who dislikes what she/he does for a living. There is a certain magnetism about people who are happy doing what they do, whether it's a garbage collector, nurse, teacher, or any livelihood you can name. We follow interest, curiosity, and passion. When it's healthy, everyone wins. It can emerge through seeing someone else doing it, reading about it, or seeing someone acting it out in a movie or on stage. You love to do it and the world needs to have it done. Fresh out of the seminary I met another minister who enjoyed painting with acrylics. That helped me recall my childhood love of

ART AND SOUL: Co-Creation and Sustainability

drawing and sparked a possibility in me. I had never before met anyone who painted. From that point on, the ferment within was active. How could I embrace that curiosity? I found a program about drawing on television and that was a beginning. One step toward my soul.

One of my favorite questions to ask someone is, "What is your dream come true?" What is the ideal for you?" I sometimes get the non-plussed look of someone who's never been asked that before. It's not surprising to me, given the blizzard of images and ideals that our consumer culture presents every day. We are easily tempted to quantify our dream financially ("be an influencer and make millions") or geographically ("live in a mountain cabin and have an internet business"), or socially ("get married and have kids"). Just hearing the question about our ideal makes life different from then on. The question can sit on the back burner of our mind and heart where an answer can show up while we're waiting at a traffic light or making the morning coffee.

When we don't know or don't follow our soul's desire, other substitutes reroute the energy and we are vulnerable to addictions of various sorts. Love to do heroin and now it's an addiction? Sorry, the world doesn't need you to be strung out like a zombie. You

Chapter 3. Our Soul's Desire

bought into an illusion and it's sucking the life out of you, and part of you knows it. Seek help. Call 988. There are people who love to help addicts recover. That may be you someday. The "high" from doing what you love, even if it's not for your whole livelihood, is better, healthier, more life giving. Maybe you have a career that buys the "toys" you prefer but it's turning out to be the "golden handcuffs" that leave you empty inside. Whether the necessity of a life review shows up as a mid-life crisis, divorce, or being laid off, it is also the opening to go deeper into the unknown. No one I know loves chaos, but it is pregnant with possibilities for a new world. All creativity starts in the fearful but fertile unknown.

As a plein air painter I sometimes hear the question from curious people passing by, "Do you do this for a living?" I hear the doubt and admiration often mixed in the question. On the one hand, if I do, that's pretty amazing. On the other hand, doesn't everybody know you "can't?" Ninety-five percent of artists have a proverbial day job. Very few support themselves totally on their art or on teaching art. What matters is what works for you. Some do not want that kind of reliance on their creative process to pay the bills. Dancers and actors sometimes wait tables between gigs. Writers today can get paid for online posting. There is another way to understand what "for a

ART AND SOUL: Co-Creation and Sustainability

living" means. When you are in touch with what your soul desires creatively, what ignites your passions, and you give it priority, time, and energy, your soul is alive and you are doing it for the kind of life you really want. This is the quality of living that sustains your imagination and feeds your soul. Ideally the day job does not sap your mental or physical energy too much, so you can return to your preference later.

In my early years as an artist when business was slow at an art fair, I looked around and realized what this was all about. On many levels this is one vast energy exchange. I was moved to create my mixed media paintings and bring them out among the public. Every artist there did the same in their media. People walked by, some commented, and when they saw something they wanted to live with or give away as a gift, the energy cycled through them. Money energy is exchanged and the work continues to engage them from then on, at home. Interest, curiosity, wonder, and passion began the work and it continued to be passed along. After seeing and hearing the Chicago Symphony I remember feeling my entire chest was enlarged with wonder and gratitude. I was moved by the most abstract art of all to a renewed appreciation for life.

Life is a vast energy exchange. Since the Big Bang the entire universe has been energy in motion non-stop.

Chapter 3. Our Soul's Desire

We didn't ask to be born, it came as a gift. What we do with it is our gift to the world. "Don't die with your music still in you." (Wayne Dyer) Discovering and following our soul's desire is a lifelong endeavor. Grandma Moses began painting at age 77. We don't know if the path ahead is safe or welcoming. Poet Robert Bly described the king energy (queen for women) as that place within that knows what you want to do for the next five minutes, the next day, the next week, and ultimately for the rest of your life. Very few know the latter early in life. Most of us study and start in one field and shift to others as we grow older. (My ex-wife is among the exceptions. In third grade she knew she wanted to be a teacher. Later she enjoyed doing it, and was fulfilled in that role until retirement). The king/queen energy may show up as an interest in playing piano, cooking, gardening, pets, or computers. We follow it by taking small actions to check it out. Take a class or workshop, read a book, or talk to people who are actively engaged in it. The next step will become apparent while continuing the work or study you are in now. Seven years into parish ministry I heard Rev. Matthew Fox give a talk at a social justice center. I brought home his brochure about the creation spirituality program in Chicago on the interconnections between art, spirituality, and social justice. I couldn't have been less interested in

ART AND SOUL: Co-Creation and Sustainability

graduate study but this one had art in it. Some cosmic fire was lit within and eight months later we moved to a near west suburb of the Windy City to begin the program. In retrospect it was a delicious foretaste of the trajectory that was ahead for me.

Questions: What is your dream come true? Is anyone you know living out your ideal life and work? Even if it is out of reach in the near term, what is one way to affirm its existence? e.g. journaling, reading a book, take a class, workshop, etc).

Chapter 4. Art As Way

"The true calling is whatever we hope to draw to us through our art, what we want it to bring us." (Gregg Levoy, Calling: Finding and Following an Authentic Life)

"The real choice then, was not between drawing, painting, or writing: brush, pencil, chisel, welding torch are simply the tools of the dialogue with one's life." (Frederick Franke, Art as a Way)

"All the arts are our apprenticeship. The big art is our life." (M.C. Richards)

"Don't play the notes, play what's not there." (Miles Davis, musician)

What you are co-creating is also co-creating you. If you are experiencing joy in your work and relationships, it enhances your health and the same for those around you. If you are caught in cycles of worry, resentment, and guilt, some valuable energy is draining out of your life. Mental, physical, and spiritual health pay a toll on that road. Art as meditation can be your oasis. For me, painting has been the path to a meaningful life no matter what I was doing in addition to that. Nothing is only what it appears to be, remember? What is the "more" that painting is for me? It is a

ART AND SOUL: Co-Creation and Sustainability

way to dialogue with my life, to reflect on what really matters, offering a taste of some of the mysterious depths of reality itself. More is communicated than the actual notes of music or the colors of paint on canvas. The way they are played and painted is just as much the message, and the heart is awakened in doing it. No one does it exactly like you or I do it. As I watch my young grandkids painting I know I am watching co-creation in action, a singular event never to be repeated in exactly the same way.

My introduction to that dialogue was in a class taught by Sister Blanche Gallagher called Painting as Meditation in the Creation Spirituality program. Using watercolor to respond to such experiences as walking among the fallen leaves or reading the mystics, I learned to let go and be guided by how the color appeared on the paper. This is the opposite of learning how to paint in the traditional sense. No "rules" or wrong here. It is an affirmation of our uniquely human capacity to make marks, to wonder and discover meaning. The medium of watercolor and the paper were teachers uniting the student with the wisdom within. This is a vital aspect of creation spirituality that begins with the goodness of creation rather than the assumption of "fallenness" that leads us to doubt that we are blessings on the earth in a universe full of blessings. It also celebrates the wisdom that unites all spiritual traditions at their

Chapter 4. Art As Way

core. This tradition within Christianity carried mainly by 12th to 14th century mystics may sound strange to many because it was relegated to the back seat by the hierarchies of the time. Catholic theologian (now Episcopalian) Matthew Fox brought it back in the late 1970s following his Ph.D. studies of 12th century mystic Meister Eckhart. (Hildegard of Bingen, Theresa of Avila, Catherine of Sienna are also from that era). This study of creation spirituality was a game changer for me because it is a spirituality juiced by creativity at its core, affirming the divinity present in creation and guiding us to respond with our gifts, expressing compassion for the needs of the world. After my Painting as Meditation class I realized for the first time that in order to be a happy camper I have to embrace the artist within me. Career counseling helped me to sort out my skills and temperament, and concluded with a series of interviews with a number of working artists to see what entry level job might appeal most to me.

Letting an art form be an anchor of sanity, relief, and centering is a valuable way to co-create our lives no matter what we do for a living. Mom worked in a hospital when I was growing up, had a garden and played piano for pleasure. Her example helped shape my appreciation of beauty. Calling art-making a hobby undervalues the activity, when in fact it is key

ART AND SOUL: Co-Creation and Sustainability

to making us who we are. What questions are older than "Who am I?" and "Why am I here?" What gifts do you want to share and/or leave behind? Any art form that appeals to you can help you dialogue with those questions. Women gather at many churches to co-create quilts out of secondhand material every week to be given away in world relief efforts. I call it love in stitches. For many of us, journaling about it can be a helpful way to process and clarify the questions and feelings that inevitably come up. We are listening for old wisdom in our body and we can be alert for new insight on this road of discovery.

When we don't know what art form appeals to us, wanting to know is what makes the difference. State your request aloud, declare your intention to a trusted friend or in a journal. Return to that question: what is your ideal, your dream come true? What makes you come alive? Where is the joy? What is the most restorative activity when you have time off? We can easily have different answers depending on whether we are alone or with others. Here is where our strongest values will assert themselves.

Several years into my part-time apprenticeship with muralist David Burnside, I discovered a workshop on art as a transformative process. Dr. Evadne McNeil left nursing to get a Ph.D in art therapy and created

Chapter 4. Art As Way

an alternative approach to other schools of thought within the art therapy world. She called it the Atira Transformation Process, named after the Native American earth goddess from whom all things come and to whom all return. This is the cyclical nature of creativity because the seed of an idea or flower can grow into its fullness or it can die of neglect and return to the earth. Nothing is really "lost." What we call breakdowns can often lead to breakthroughs. What appears to be an obstacle can become the gift of a new beginning that renews and strengthens life. I enrolled in her program around the same time that I began part-time chaplaincy in prison. After a three-year period of study I became certified as an Atira (Transformation) Practitioner (CAP). This process embodies an educational model where we are all learners unlike some medical models where someone is sick and someone is well. This path of being an expressive arts teacher appealed to me more than becoming a registered art therapist.

I co-created an Art and Soul workshop to help people welcome their creativity in a safe environment. Using simple crayons, oil pastels, or tempera paint the invitation is to stay open to what you feel in the present moment, beginning with a crayon or oil pastel on paper. As adults, our inner critic is well practiced and quick to judge. Since no judgment of

Chapter 4. Art As Way

an alternative approach to other schools of thought within the art therapy world. She called it the Atira Transformation Process, named after the Native American earth goddess from whom all things come and to whom all return. This is the cyclical nature of creativity because the seed of an idea or flower can grow into its fullness or it can die of neglect and return to the earth. Nothing is really "lost." What we call breakdowns can often lead to breakthroughs. What appears to be an obstacle can become the gift of a new beginning that renews and strengthens life. I enrolled in her program around the same time that I began part-time chaplaincy in prison. After a three-year period of study I became certified as an Atira (Transformation) Practitioner (CAP). This process embodies an educational model where we are all learners unlike some medical models where someone is sick and someone is well. This path of being an expressive arts teacher appealed to me more than becoming a registered art therapist.

I co-created an Art and Soul workshop to help people welcome their creativity in a safe environment. Using simple crayons, oil pastels, or tempera paint the invitation is to stay open to what you feel in the present moment, beginning with a crayon or oil pastel on paper. As adults, our inner critic is well practiced and quick to judge. Since no judgment of

ART AND SOUL: Co-Creation and Sustainability

anyone or anything that is made is allowed in the experience, people tend to soften into the newness of making marks, shapes or whatever shows up. My role is to maintain the safe space of non-judgment and to attend the process in a supportive way. There is no "expert" in the room. Here we are all teachers and learners. The images that are made become places to hold us in the present moment and feeling, an invitation to dialogue. Like dreams there is no single "meaning" and it is always what the maker of it is willing to see and hear in their own words. This is not art therapy but since all art-making is therapeutic, it can be healing in its own way.

When I led weekly sessions in an addiction treatment center, a new arrival might say, "But I'm no artist." I always replied, "You're in the right place." All that is necessary is to be able to hold a crayon and be open to possibilities. In some cases people have been wounded by a teacher or parent who was dismissive about their artistic ability such as in music or visual art. That can be enough to shut down interest and replace natural curiosity with a sharper inner critic. The critical inner voice seems to arrive in a child around age ten anyway so it takes parents and teachers with sensitivity to encourage them so they don't hear the critical voice as the last word about who they are or what their potential might be.

Chapter 4. Art As Way

There are many ways that art can be a way, a path to self discovery and even a spiritual discipline. I will cite just a few. These are based on three aspects of human development. First, we have wisdom in our bodies. We have a felt sense of what rings true, what is healthy and life-giving. (Caveat: I realize various forms of mental illness can skew this sensitivity for unhealthy and even twisted ends). Wisdom has been passed down through spiritual traditions as well, and we benefit from those, too. Second, evolution occurs in the present moment, so it is vitally important to learn how to stay "here" rather than in the past or the imagined future. "Fear separates us from life. Sadness connects us to life. Let the sadness be." (Robert Augustus Masters) Third, unconditional love is the fertile soil for human flourishing and a sustainable planet. Acceptance as we are right now is at the core of physical, mental and spiritual health. You can't be you if you are trying to be a different version of someone else. Since everything in the universe exists in relationship to everything else, how we enter our relationships influences what is possible in a given moment. Entering to "win" sets up power differentials. Openness to what's possible, to what we can co-create together in love and respect is an embossed card invitation to a new and exciting future.

ART AND SOUL: Co-Creation and Sustainability

One example of art as a way is by Frederick Franck in his book of the same name. Published in his handwritten script with ink drawings, Art as a Way is a challenge to all our ego-invested notions of "creative" and "artist." "To draw is to forget the name of what is drawn." Begin by drawing an object without looking at your paper. It annoys our controlling ego that wants to get it "right." Done regularly, we develop trust that what the eye sees, the hand can relate to in some intimate way. This is art as letting go, as a meditation on the "being-ness" of any given thing, experience, or person. We may discover our unity with all things. Among the many lessons nature teaches us is the art of letting go. If you are carrying many kinds of stress, here is some medicine free of charge. With or without your preferred music, these moments shift us from a calendar and achievement frame of mind to attending to and being in the moment. The judgmental chatter of "What good is this?" Will be there too, but with patience we can experience the restorative "now." "The soul has an absolute, unforgiving need for regular excursions into enchantment. It requires them like the body needs food and the mind needs thought. We have yet to learn that we can't survive without enchantment and that the loss of it is killing us." (Thomas Moore, Care of the Soul).

Chapter 4. Art As Way

My first art class Painting as Meditation introduced me to this practice using watercolor. At times we blew through straws to move the color on the paper. We walked with awareness among the trees and brought the experience to the watercolor paper. Less thinking and more focus on direct experience was the key to my awakening to the deep river of joy within that led me to the program in the first place. The body never lies. As poet Mary Oliver wrote: "We have to let the soft animal of our body love what it loves." If fear and anxiety are more present, then stay with it. The marks on the paper may reflect it. The experience of letting go with color was a revelation of the healing power and potential of being present to this very moment.

We all have a lot of stories about why things are the way they are and the way we are. That's what humans do. Current technology unfortunately allows some pretty wacky stories to proliferate and distract us. All the art forms serve to help us see our stories and to explore more deeply than our stories, to discover another point of view. In that sense they can act as a mirror. We see what we see when we are ready to see it. "We live in a description of reality." (Jean Houston) I've been fascinated by this subject for decades. I can live in regret for not writing this until now, or celebrate that it is now happening. The world of coulda, woulda, shoulda has no real power. Today

ART AND SOUL: Co-Creation and Sustainability

has power. Now is reality. Now is what is arising. All the yesterdays are stories of achievement and disappointment, looking good and looking bad, blessings and regret. Oprah says "forgiveness is giving up the hope that the past could be any different." Forgiveness finishes business and emboldens our freedom to co-create a new world of possibility in the here and now.

My Art and Soul workshops are an embodiment of those possibilities. A space where no judgment is allowed, either of anybody or of anything they've made. Using simple materials, crayons, oil pastels, dry pastels, colored pencils participants are invited to stay in their present feelings and explore letting go, play, and wandering with color. What would happen if I used my opposite hand? Or closed my eyes while I color? Most of us have not allowed ourselves to create without a "why." This is a space of listening and wandering with color in hand, attending to what occurs within and being open to discovery. We have tried to live by staying within the lines of instructions or assumptions we are only partially aware of. This is another way to let go and see what discovery lies on the other side of our habitual ways of doing things. The opportunity to share in safety about what showed up within and on the paper is optional but most welcome it. My role as an expressive arts teacher

Chapter 4. Art As Way

is to maintain the safe boundary of non-judgment and actively listen to each one's sharing of feelings and observations. Something new and healing can happen in another's listening. "Something is always born of excess: great art was born of great terrors, great loneliness, great inhibitions, instabilities, and it always balances them." (Diary of Anais Nin) Ultimately, only the creator of a piece of art knows its significance. This is co-creation in action: each piece is an expression unique to that moment. How it resonates with what they feel at the time interfaces with what's on the paper to arrive at what's "true" in this moment. Processing these images on our own can be learned over time so that it can be a form of regular meditation. Nothing can be made that we are not "ready" for. Everyone has a safety valve within, call it body wisdom, that reveals itself as we are ready and open to it. We see what we see when we are ready to see it.

Questions: Who is living the life you admire?

What have you learned from failure? Did anyone help you through it?

Chapter 5. Resistance and Release

Be careful what you resist lest you become it.
—Anonymous

"The ego is sustained by continuous resistance."
Eckhart Tolle

Resistance protects that which I have practiced becoming. —Anonymous

"Sometimes…I look out at everything growing so wildly and faithfully beneath the sky and wonder why we are the one terrible part of creation privileged to refuse our flowering."
—David Whyte, "The Sun"

"Paintings wait for us."
Julia Cameron The Artist's Way

At the deepest level the creative process and the healing process arise from a single source. When you are an artist, you are a healer.
—Rachel Naomi Remen

At the time of this writing there are about 8 billion ways to live a human life. Each one is unique, never to be repeated. We are alive now to "flower" in countless

ways before we die and our song concludes. We do well to get accustomed to mystery, life's confounding puzzles without a solution, pieces missing, etc. We do our best to protect our hearts from too much chaos, uncertainty, and pain that inevitably come with the knowledge of our mortality. When Wayne Dyer said "Don't die with your music still in you," he was pointing at the resistance (fear) that accompanies all human co-creating. It might not "work." I may fail. I don't know where to start. The good news is we are all in the same boat. Homo sapiens inherited the limbic brain to protect itself from the vast uncertainties in a world before fences and hand-built walls. It may appear that others co-create with ease, but rest assured, everyone goes through the forest of doubts, the valleys of uncertainty one step at a time. As writer Audre Lorde says, "Poetry is the way we help give name to the nameless so it can be a thought. The farthest horizons of our hopes and fears are cobbled by our poems, carved from the rock experiences of our lives." Every painting began with a single brushstroke. My own definition of painting is "pick it up and lay it down." Brush, palette knife, gloved fingers, squirt bottle, whatever you have will be useful in the beginning of the only piece in the whole world exactly like yours. The way you co-create has your unique "fingerprint." As the universe

Chapter 5. Resistance and Release

emerged out of the "void" so does your co-creation. And there is more where that came from.

"When we take one step toward our soul, our soul takes two steps toward us." (Robert Bly) Fear is our lifetime companion, but it doesn't have to be a dictator. We know we are stepping into unfamiliar territory. Few writers have hit a cultural nerve as accurately as Julia Cameron did in her book, The Artist's Way. It remained on the national bestseller list for many years. Addressing the persistent desire of people to create, she offers a deep dive into the many fears and "blocks" that people naturally encounter on that path. One of my favorite stories she wrote is of a woman in her 60s who always wanted to learn to play the piano. "Do you know how old I'll be by the time I learn to play the piano?" Wisely, Julia replied, "Yes, the same age you'll be if you don't." One of the gifts of our mortality is the realization that our time on earth is limited. If we are learning life's daily lesson of letting go (nature is whispering this every day), we can take courage that there is no time like the present to step up to our dreams, our hopes, our vision for what can be. My expressive arts teacher, Evadne McNeil, said, "The really important things in life we get to learn over and over." The vitality of a sense of humor, the power of a smile, sunsets and flowers that elicit our awe, the knowledge that we are surrounded

ART AND SOUL: Co-Creation and Sustainability

in divine love no matter what, the soul nourishment in a heartfelt hug, being genuinely heard without judgment, are among the most important things in life for me. You can add many more.

We are used to prioritizing the value of the result in any art-making. We want the painting to look right, the wood furniture to function well, the clay pot to feel good in our hands, the dance to occur without someone tripping. Doing our best work is the proper role for the "inner critic" that needs a job to do: more of this color, a softer edge, more emphasis on this line of music, etc. When aesthetic concerns are left unattended, the critic within is ready sap our energy with immobilizing fear and disabling doubt. "Our doubts are traitors, and make us lose the good we oft might win, by failing to attempt." (Shakespeare) How we do anything is how we do everything. The act of co-creation is being in touch with something beyond ourselves. Sometimes a surprise shows up on the canvas that you didn't think you put there. A spontaneous harmony comes from your voice that you didn't rehearse. Every night we dream images, sounds, colors that we have no control over. When I write them down soon after waking, I welcome a dialogue that can offer both insight and abiding mystery that is always at the center of life. Dreams walk with us into our daily life and work. More is

Chapter 5. Resistance and Release

happening as we co-create our lives than we can quantify. Being less attached to the immediate results of a given creative act is a freedom we all deserve.

On the way to our dreams of what we can become, our fear shows up. Fear and intuition reside together in our belly (second chakra). Thinking of changing jobs? The fear of leaving, surviving, upsetting your spouse or family, losing your home, all show up at the door. If you've always wanted to learn to play the piano, fear of failure is a likely companion down that road. We love comfort and the familiar. We dread stepping out of our comfort zones. Our egos hate being judged or criticized. Leaving parish ministry in my mid-30s was risky, but my wife saw the importance of the career shift sooner than I did and supported it. I am thankful beyond measure to her and our three beautiful kids who were 10, 8, and 6 at the time I made the shift. The standard wisdom would have advised letting art be a hobby. Go whole hog when I retire. Growing up without Dad who died of cancer at 52 shortly after I was born, I knew that some people don't live until retirement. I couldn't wait. My congregation, Community of Christ the Servant, was an experimenting expression within the national church body that preceded the ELCA, and very creative. They understood my need to pursue my dream, and supported my departure. To this day

ART AND SOUL: Co-Creation and Sustainability

I recall the feeling of gratitude and exhilaration as I set out on the road to my dream.

Three years into my apprenticeship with mural artist Dave Burnside I was talking with my mother on the phone when she said, "You can't make a living from your art." Hers was an understandable response as I look back now, since she lived on a farm through the Depression of the 1930s. But in that moment it was like a dagger to my heart, killing my dream. But I didn't tell her that. I said I was working with an artist who was making a living from art. She died a year later. What followed was typical of anyone being told, "You can't do, have, or be ____" (fill in the blank). My "I'll show you" reaction slipped into the background of my awareness. Can you co-create your art or your life with resentment on the back burner? Sure, our motives are almost always mixed, rarely pure. In fact, any art form of choice can be the perfect channel for releasing the gravity and depth of human emotion from powerful love to the deepest grief and loss. Indeed that is the history of art. "The human heart in conflict with itself is the only thing worth writing about." (William Faulkner)

However, certain resentments can be toxic over time. Resentment, they say, is the poison that we swallow hoping someone else will die. I was attending a

Chapter 5. Resistance and Release

Landmark Forum weekend when the leader/teacher said, "Forgiveness is giving up the right to resent." You would think these words would not sound new to someone who studied theology. In that moment my heart was a student ready for the teacher to appear. I knew I had something to settle with Mom who died 16 years prior. As I was driving home it occurred to me to say out loud what I realized was true, "Mom, I forgive you for saying I can't make a living from my art." Days later I realized the resentment was even deeper: I said, "I forgive you for not marrying again and giving me a dad." That one hit my core. Tears ran down my cheeks. Such an awakening and release became a day of being light on my feet, an effervescent joy within my smile. I was smiling so much I couldn't sleep that night. I finally got up at 3 a.m. to write about my experience on the computer to my adult kids who lived in other towns. Carrying resentment subconsciously until I was ready to name it was stifling my deep joy in the wondrous beauty of life. What followed was this question: In what other ways could I be living the resentment story of "You didn't give me ____"(fill in the blank)? Who else and what other opportunities were seen through that lens of resentment and therefore justified my resistance? Here is the kicker: in what ways have I not given myself the good things I deserve? Did I

ever ask for it? The most important things in life (and they are usually not things) we get to learn over and over. Co-creating with forgiveness is very beautiful! Jesus knew how easily a human heart could hang on to "unfinished business" and clog up our ability to experience the freedom and joy of boundless divine love in a complicated world. Our egos would prefer deserving and fairness to rule the day.

I love what Jean Houston said, "Our wounds are the entry places of the divine." It gives the wretched part of human existence a place in the "choir" of our life. No one goes through life without wounds. We can either hang on to them, possibly take them to our grave believing we were "right," or let them go in what God specializes in: forgiveness. No one gets the first place medal for hanging on to old hurts. Everyone gets more freedom, peace of mind and likely better health from forgiveness. The ancient wisdom "To err is human, to forgive is divine," is a window into the history of civilization with too much emphasis on the first part. Years of journaling, therapy, art-making, men's groups, and workshops preceded my epiphany. I was ready to hear it and my body didn't lie. I was ready to be free of my previously unknown toxic resentment. In my understanding of theology, God is working throughout the entire creation. There is no barren place where we can't be reached. Love wins.

Chapter 5. Resistance and Release

Letting go is the lifelong lesson we get to learn over and over. Nature is the champion teacher of it and all art-making is an exercise in it. What we are creating is also co-creating us. We can co-create from our anger, grief, and loss. We can also co-create out of our joy, exuberance, wonder, or simple exploration. Both have transformative potential. My career counselor told me at the beginning of my art journey, "You would do well to soften your inner critic." Art-making has indeed been a healing journey in that for me!

What do I want my art to bring to me? Initially for me it was the joy of a dream fulfilled, living in integrity with my gifts, the pleasure of expressing visually with my heart and hands what I love and value. There is an authenticity in honoring your heart's desire with some of your time, energy and money. The soul and psyche of the planet would shrivel and die if the dances weren't danced, the music played and sung, the paintings painted, or the novels written. Indeed every art form is a natural and essential expression of our soul. But we are experts at resisting. The neurotic in each of us "would rather stay in control than RISK getting what we really want." (Anne Wilson Schaef) Realize that we get something out of our resistance in addition to staying "safe." Naming how we do the resistance is a valuable first step. Rationalizing, eating, texting, scrolling social media, surfing the internet,

there are myriad ways. There is a reason we blithely refer to "rabbit holes" and "black holes" referring to the internet. Mindfulness will recognize when these actions are functional and when they become dysfunctional. A wise teacher said, "Be careful what you resist lest you become it." Try expressing your fears about embracing your creative imagination at a cemetery. Was awareness of her mortality what helped Grandma Moses take up painting at age 77? What we are really seeking, I believe, cannot be quantified, like truth, love, and joy that transcends happiness by far. Paintings are not the truth, but they point at it. Dances are not the truth but they point at it. We are the only species gifted with imagination and every commercial on TV and billboard is aimed at it. In American culture our imaginations are at high risk of being colonized by consumerism. Addiction makes us want more and more of what's not working. Happiness, success, popularity, acceptance can be purchased, and (winking) if you order now you can get a second one for half price. Lottery winners do not have a great track record of long-standing happiness. There is something deeper we desire that does not come easily or with a click of the mouse.

Chapter 5. Resistance and Release

Questions: Write about the time you reached your limit in a job or activity. What did you take away from the experience?

What experience is hardest for you to let go of? Is your health telling you something about it?

When did your inner critic stop you from starting or continuing what you wanted to do?

Chapter 6. What's Mything (in My Life)?

> "The visible is only the shoreline of the magnificent ocean of the invisible."
> (John O'Donohue, Eternal Echoes)

> "Dreams are private myths and myths are public dreams." (Joseph Campbell)

There are times when you get a powerful sense of life being larger than your individual story. When disaster destroys your home but not your life, when a person or pet close to you dies, when you come away from a live theater performance that touched your heart, etc. I was glad to be present for the birth of my children and cannot describe in words the marvel and wonder of it all. Our words can only point at reality that transcends our naming. There are patterns, though, that continue to appear over the millennia, deep structures that permeate all of life. The most helpful definition of myth for me is "something that never occurred but is always happening." (Jean Houston). There is no chubby cherub with a bow and arrow but people keep falling in love. How do dreams keep happening every night? The ancient Greeks said Hermes is the messenger that continues to bring us more images of the stories that we are living. What

kept happening in my life were encounters with artists, art, and the beauty and joy of being in nature. Science can tell us much about the "what and how" of life, but we also want to know the "why." Some say that the two most important days in our life are the day we are born and the day we know why. We have different answers at different ages to this purpose question. When we don't know why, we drift with a vague awareness of ennui and disconnection. We are in search mode and vulnerable to that bag of chips on the shelf.

I will always remember reading for the first time the story of the Greek god Hephaestus, the only god on Mt Olympus that worked with his hands. He was rejected for some defect at birth by Zeus and his mother Hera. He is the god of the forge who made beautiful things with his hands. In her book Gods in Everyman, Jean Shinoda Bolen describes the various archetypes (universal patterns across all cultures), including this one of the god/artist Hephaestus, how he/she looks at life, what he/she prefers, fears, and loves. When I read it I felt like I was seeing my life story from 20 miles above the earth. The mythic ground shifted under me. I was in my early years of working as a part-time apprentice to an artist and I felt a joyful, powerful connection to a Big Story, immensely larger than me. From the mythological

Chapter 6. What's Mything (in My Life)?

perspective, all of the energies of the gods for men and goddesses for women are available to us all. We come into this world with natural tendencies and preferences that can develop into knowledge, skills, and a way of life. Hera, for example, is the goddess of marriage and family. If you are a dedicated wife and mother, this archetype is expressing itself in those priorities and values in your life. Other archetypes are always available but certain ones will be a natural "fit," and others will seem "not like me, not my way of doing life."

James Hillman was a Jungian analyst who left the mainstream of psychological practice and beliefs in favor of a more soulful way of working with our inner lives. Just as the acorn has all that is needed to become an oak tree, so each of us is born with a particular image, an essence of life that calls us to a destiny. The Greeks called it "daimon," the Romans called it "genius," Christians sometimes call it "guardian angel." In his book The Soul's Code: In Search of Character and Calling he used these words interchangeably. Today we often use the terms heart, spirit, and soul. What shifted in 6-year-old Ella Fitzgerald when she stepped on the stage to dance, but changed her mind and sang instead? Her gifted voice became legendary. My Lutheran school fifth grade teacher told my mother that she

ART AND SOUL: Co-Creation and Sustainability

saw "ministry material" in me. She was right but it turned out to be more fitting in prison chaplaincy than in parish ministry. Within the first seven years I met two ministers who were also artists and I lit up inside. Hillman would say my daimon guided me to them. I see it now as a calling and it is a joy to live it. Some like to use the word "talent." I don't. Whatever that is, I think, is seen only in the rear view mirror. Sustained interest and curiosity lead the way to skill and mastery. Down that road, experience will either validate it or call for a course correction. When I started selling my paintings in art fairs (late 80s and early 90s) I realized I was paid twice, once in the joy of co-creating the work and again when it sold, in seeing it go to a happy home.

Many people I know were educated in one field and now work in a different one. For many reasons few in our culture seem to follow the "gold watch upon retirement" path of the same livelihood their entire career. The quarter-life crisis is now occurring along with the proverbial mid-life crisis that sometimes results in a career change In my case, depression was a signal that something was missing. If this is your reality, it is an invitation to revisit your dreams. What would I do if I could do anything at all in the universe? We know it's not a case of Jack Daniels on a beach in Mexico. Boredom would set in sooner or

Chapter 6. What's Mything (in My Life)?

later if you survived the booze. Is there something greater than yourself that you belong to or a cause that inspires you? I've always thought of a job as something I do for money and of work as what I would do even if I wasn't paid for it. It's a match made in heaven. It's where our deep gladness meets the world's need. Practicality may mean doing your present job to support yourself and those you love. As long as there is a commitment to discover what your real work (heart's desire) is, your present job can keep body and soul together. World renowned mythologist Joseph Campbell believed people are seeking more than meaning in life. "I think what we're seeking is an experience of being alive so that our life experiences on the purely physical plane will have resonances with our innermost being and reality, so that we actually feel the rapture of being alive."

If you live on the edge of existence, this sounds like a fantasy. Seven hundred nineteen million people on the planet live on less than $2 a day. Almost half of the world's population (3.4 billion) live on less than $5.50 a day. Their co-creative energy is focused daily on survival. Precious few in America have any clue about how they do it. Imagination is contained by suffering, lack, and threadbare hopes. My work as a chaplain among incarcerated men, including some with life sentences, gave me a glimpse of the power of the

human spirit to endure amidst stiff odds. They taught me about faith and resilience, the power of family relationships and the significance of being present with them in crisis. Imagination is in our essence as human beings. I read their poetry and heard rap songs created in a cell accompanied by hand drumming on the wall. One showed me his sculpted model '57 Chevy made from toilet paper and colored with Kool Aid powder and water. The most moving of all the art pieces made in jail was from a young man placed in solitary because he was in a mental health crisis and needed to be prevented from harming himself. No book, pencil or paper, only himself wrapped in a velcro-secured, long "shirt." During our conversation I noticed a white object on his cell window sill. He showed me a rose on a stem he had made from only toilet paper. Delicate petals intersecting just as nature makes them. Knowing the power and agency of co-creating something tender and beautiful, especially in his stressed state of mind, I said, "Would you make one of those for me?" He did and gave it to me and it remained a symbol of the beauty that is the deepest center in all of our lives. I prayed with him and knew that he was at least in touch with the God-given dignity we all share. Thankfully he made it through that nightmare in his life.

Chapter 6. What's Mything (in My Life)?

We all function with limited perceptions of our reality. The atoms in our body are 99.9 (add many more 9's) percent empty space and none of them are the ones we were born with, but they all originated in the belly of a star. All of the beautiful colors we see represent less than 1 percent of the electromagnetic spectrum. Pretty hard to judge other human beings with such little information, but fear will do it every time. Without wisdom we are like the blind leading the blind. It's been said that we are spiritual beings having a human experience. Any art form can help us dialogue with the unnameable, the ultimate why and source of our life. It is one reason we have so many art forms. Imagination is endless. It is also why story is in our genes. The deepest stories and myths became the life work of Joseph Campbell. His wife, Jean Erdman, was a dancer. When asked how the new myth for the earth's future might come about, he said, "It will have to be those who are awakened to the imaginative life, the artists, poets, and certainly the dancers." His wife interjected laughingly, "What you mystics forget, is that in order to be in touch with the universe, you have to have a craft." What we do with our bodies and hands is important, especially in relation to our imaginations. We've always had the essential "media" that the earth has given us in addition to our own bodies (movement/dance), pigment, wood, clay,

ART AND SOUL: Co-Creation and Sustainability

music, etc. and new ones continue to emerge. The advent of the computer has brought both blessing and challenge, and now we have the "primordial fire" of artificial intelligence at our disposal. Seen as the holy grail by some and a slippery ride over the cliff by others, can it be a "craft?" The wise warnings of those who have been at the forefront of co-creating AI are calling for important guardrails on its development. Here again our imaginations help us to keep an eye on our moral compass and the immense power of our creativity in relation to the real needs of humanity and all the species with which we share this garden planet.

What stories have stayed in your memory for a long time (books, movies, religious teachings, etc.)? Who are your heroes/heroines?

Who is living out your idea of the "ideal life?"

What lights up your day? What dims or turns the light off?

Chapter 7. Distractions

We have been living in the attention economy for a while now. Digital technology permeates our lives, and we have a generation emerging that knows no world without the little screens we hold in our hands to do endless tasks for us. Most of my grandkids have cell phones or a smart watch, at least for security purposes. While computers have placed everything from the Library of Congress to restaurant opening hours at our command, our human imagination is being stressed and stretched. Family life, fraud, news, marketing, the entire scope of human existence is happening on our screens 24/7, 365. How long can they keep our attention on this "shiny thing," notification, or human drama? I am not slamming the immense gifts that the digital revolution has brought us. I am writing this on an iMac with gratitude for the relative ease it affords me in this process. I appreciate being able to stay in contact with important people on the various devices we use. Zoom gatherings with family in other states felt like life-savers during the isolating restrictions of the Covid pandemic. I am calling attention to our attention and who or what gets it and for how long. Each of us can discover at what point the technology has become a distraction or even a curse. When does the screen "take over"

ART AND SOUL: Co-Creation and Sustainability

so that we lose touch with what is fundamental in our humanity: our imaginations and souls that depend on in-person conversations, seeing another person's eyes as they express the vitality of this moment? What stays in our memory, the text, email someone sent, or the time we walked together in the forest preserve or had coffee together? Some of the designers of Facebook and Google do not let their kids have access to certain social media apps because they know the addictive qualities that are built into them. That speaks loudly to the dangers we are facing going forward. The mental health crisis among young people has risen sharply since 2007 when smart phones began their exponential rise in popularity. Dr. Jonathan Haidt of Columbia University in his book The Anxious Generation calls an all out alert to us all about Gen Z, kids born after 1997. The meteoric rise in rates of anxiety and depression are unprecedented among boys but especially among girls. Check out his YouTube video Smartphones vs. Smart Kids where he presents the data and the changes he is calling for. Normal brain development requires real in-person play, risk and problem solving that most adults took for granted growing up. This is far less common since smartphones became ubiquitous. We can laugh, but there is an emerging revival in sales of flip phones.

Chapter 7. Distractions

California artist and writer Jenny Odell grapples with these issues in her bestselling book "How to Do Nothing: Resisting the Attention Economy." In order to withdraw our attention from something, we need to place it somewhere else. She chose bird watching as an activity that keeps her soul alive. There is no more fundamental relationship than our connection to the life-sustaining earth. It is the source of everything we are and have. Why else would people travel to the lake or the cabin in the woods on their weekend time off? Art-making can achieve the same "time away" or escape while staying at home. Squeeze out paint, turn on the music, and you have an invitation to another realm. Yes, fears come along too, but what better place in which to teach them with play time, that they are not the last word about me, my time, or my worth? Psalm 46:10 has been a meditation mantra for me for many years: "Be still and know that I am God." Repeat it slowly and drop off one word at the end after each out-breath until the only word left is "be." "Only if we are still enough inside and the noise of thinking subsides," says Eckhart Tolle, "can we become aware that there is a hidden harmony here (in nature), a sacredness, a higher order in which everything has its perfect place and could not be other than what it is and the way it is." Art-making is meditation with our eyes wide open and focused on this moment, sensation, and movement.

ART AND SOUL: Co-Creation and Sustainability

Clearly the ubiquitous nature of technology requires a conscious decision as to how much we can live with and live without. Georgetown University computer science professor Cal Newport offers guidance in his bestseller, Digital Minimalism: Choosing a Focused Life in a Noisy World. One option is to delete social media from our phones so that activity is limited to another device. Deleting notifications can be another step toward more focus and clarity. One reason why "clickbait" is so persistent is the randomness with which we check our devices. The algorithm is designed to give you more of what you pay attention to. Clear intention about what we want from our devices is qualitatively different from internet-surfing and doom-scrolling. Intention is a brain and heart "muscle" that is being challenged by our high tech culture. When I've reached my limit of screen time I need to go for a walk, write with a pen, paint; anything with my hands or body in some kind of motion. What better time to reflect on our priorities and values? What better time to let the silence be and hear our heart's longing for open and quieter space?

One of my daughters has an upper management position in a company that allows her to balance working from home with office time. Recently she experienced insomnia and minimal sleep for weeks at a time. She tried every remedy, consulted

Chapter 7. Distractions

with a doctor, turned off devices by 6 p.m. and, intensified her yoga practice, yet still had difficulty turning her mind/body "off" so she could sleep. Her breakthrough occurred when she returned to her dormant interest in painting and music. She heeded the voice within that needed to be heard and expressed in the symbolic language essential to our very being. Words can't always say what needs saying and can even get in the way at times. We are too deep and complex. Just as drums echo our heartbeats, and body movement finds its expression in dance, the wide variety of visual expression, whether in color or shape, evokes the yearnings of our hearts.

A friend at church shared with me a practice of going outside every day to sit and do nothing but observe and listen for a half hour. I was amazed when I tried it. It goes against my protestant work ethic of always accomplishing something. It brings me face to face with my "monkey mind" to consider the possibility that the earth itself could teach me something (e.g., balance, letting go). Our bodies have wisdom. Can we hear it? What have we traded for being constantly "on" and busy every waking moment? Literally hundreds of scientific studies have proven the mental and physical benefits of a regular meditation practice. Every spiritual tradition offers various forms of meditation. Yoga has been a favorite

ART AND SOUL: Co-Creation and Sustainability

of mine for many years. All art-making taps into the same stream of mindfulness and meditation.

What have you found is the most helpful and nourishing practice for staying balanced?

If you journal your thoughts and maybe your dreams, has it been helpful to review past entries occasionally?

What is your preferred active form of meditation?

Chapter 8. Co-Creation and Sustainability

> "As spiritual adults we accept responsibility for co-creating our lives and our health. Co-creation is in fact the essence of spiritual adulthood. It is the exercise of choice and the acceptance of responsibility for those choices."
> (Caroline Myss, The Anatomy of the Spirit. p. 67)

At the turn of the millennium I was feeling burned out after too many house painting jobs and too little painting as art. I needed a retreat to recover my artistic soul. In October 2001, I spent a month at the Vermont Studio Center in Johnson, Vermont. As a small community of writers, painters, and sculptors we raised the question, "Is this really the right thing to be doing while the country is in shock over the terrorist attack on September 11th?" We were creating art while the spirit of revenge was sweeping the country and young people were enlisting in the military. The so-called "war on terror" had begun and the bells of patriotism were ringing. Surely evil must be held accountable, but in what way? Over the course of a few days we arrived at a consensus: indeed art-making is what we should be doing because it is one of the most authentic ways we know to respond

to the complexities of life. Hopefully as many people as possible found healthy ways to express their anger, grief and their hopes for a better tomorrow.

I hope by now I have made clear my case that 1) creativity is universal and embedded in all of humanity; and 2) as we embrace the search for and/or the practice of our deepest gladness, persistent interests, and curiosities, we will grow into our healthiest, most balanced and compassionate lives. This has been my experience as an artist, a chaplain working with incarcerated people, a teacher of expressive arts process, and as a husband, father, and grandfather. We co-create our lives one hour, one day at a time, working with the raw material of our health, experience, dreams, relationships and jobs, even the weather, grounded in life-sustaining Mother Earth, and for many, a heart-sustaining faith in an ever-loving God who chose to use all of the above to reveal, nourish, and guide us. What we do with our hands and hearts is important. Today is this awesome gift and blessing that is powerfully pregnant with possibility.

How is this time different from when we grew up? Life may appear to be the same ol' same ol', but we have in fact entered a new era. The Holocene age that began around 12,000 years ago, after the ice age retreated,

Chapter 8. Co-Creation and Sustainability

has given way to the Anthropocene age, the age of the human. Some scientists place its beginning in the 1950s. Today is a different era because our human presence on the earth is fundamentally changing the way the earth functions. Now, with eight billion people and counting, our consumerism, mining, burning of carbon, agriculture and food waste have become the global equivalent of the natural forces of the jet streams, tectonic plate shifts, and all the life systems that have hitherto supported life on this blue dot in the Milky Way galaxy. We have come face to face with the biggest challenge to human imagination ever: how do we collectively find and co-create a sustainable way of life together? No credible scientist can look at the data of 40 years of steadily rising CO_2 levels in the atmosphere, disappearing glaciers and sea ice –the years 2016 to 2023 being the hottest on record so far– and say we are not facing an existential crisis of epic proportions. Yet denial is everywhere in our culture. In the addiction recovery world, the saying is, "Nothing changes until it is what it is." Naming our current circumstances truthfully is the essential first step toward any possible solutions. As I said before, nothing is only what it appears to be. It is always more. Could our present challenges also be an invitation to co-create a deeper, more authentic way of life? Instead of chasing the myth of

ART AND SOUL: Co-Creation and Sustainability

progress that says more and bigger is always better, can we embrace the earth's model of sufficiency? There is enough food on the planet to feed everyone. Unequal distribution of wealth and resources, greed, fear and political division co-create the imbalance and hunger. The rising numbers of climate refugees are the equivalent of a fever in the body politic. Deep listening is required to receive the diagnosis and respond with compassion. Conversations from "silo to silo" on the internet are adding to the current alienation we are experiencing. We need real in-person conversations as much as possible (OK, some zooms and FaceTimes could help, reducing air travel). Remember that surreal, warped feeling of social distancing during the Covid pandemic? We all thrive on embodied communication that co-creates understanding on a cellular level.

It may seem like a stretch to talk about human creativity and climate change in the same book. Yet what else is it but a result of human priorities? A tug of war between love and fear, individually and together? We are the only species entrusted with imagination, reason, and choice about how to do life. Eighty years ago there were no nuclear ballistic submarines. Now there are at least 45 worldwide. History has shown that we are capable of co-creating various forms of war and peace, justice and injustice, with or without

Chapter 8. Co-Creation and Sustainability

religious inspiration. Countless sages and models of love and justice have led the way to compassionate breakthroughs over the course of human history: Buddha, Jesus, and Muhammad, among others. Moved by something larger than themselves, beyond self-interest, they co-created with their words and actions a way of life that is sustainable because love is at the center. Yes, their followers have inconsistent results because we are a complicated species. We have the same choice today: to act out of love or fear. This is obvious to anyone who has longed to embrace the co-creative energies within, in order to live as authentically as possible.

One of the first shifts of consciousness that is necessary is what the Native people have always known: the interrelated nature of all things. What we do to the land and water we do to ourselves. We exist in a long chain of being with the animals, birds, insects, and micronutrients in the soil. "Geologian" Thomas Berry said, "We are the earth become conscious of itself." (A theologian who knew the deep evolutionary story of the universe). All of our ability to co-create with life on earth depends on a healthy and sustainable relationship with every life-sustaining element on earth. Our grandchildren depend on our best wisdom and understanding leading to a truly sustainable way of life. In his book The Great Work, Thomas Berry

wrote, "Perhaps the most valuable heritage we an provide for future generations is some sense of the Great Work that is before them of moving the human project from its devastating exploitation to a benign presence. Each age has only what it receives from the prior generation. The Great Work... is not a role we have chosen. Yet we must believe that those powers that assign our role must in that same act bestow upon us the ability to fulfill this role. We must believe that we are cared for and guided by these same powers that bring us into being." (p. 7)

I realize most people are just trying to make a decent living and have a little time off. The beauty of co-creating the ideal sustainable lifestyle may seem way out of reach. Global issues are for someone else to figure out. Certainly government and business do have a vital role and need to be held accountable within our public trust for the common good. There is enough for everyone's need but not our greed. Our individual choices do need to stand up to the "mirror test." Am I able to say to myself in the mirror that I am living in integrity with my gifts and responsibilities? Or is someone or something else "driving my bus?" This is where an art form can serve to explore the deeper questions of our soul: who am I and why am I here? What practice(s) would help restore my depleted energy and my longing for meaning and

Chapter 8. Co-Creation and Sustainability

purpose? Are there groups, faith communities, or classes where I can get support in my search? I appreciate what social activist and author Margaret Wheatley says: "Whatever the problem, community is the answer." In a country awash in loneliness it's hard to imagine a sweeter medicine. We can do some healing by ourselves, but the level that is needed today can only be addressed by healthy communities of every kind.

In the end we will never fully understand the great mysteries that make life so unspeakably beautiful and wondrous on the one hand, and so tragically sad and painful on the other. "Art is a placeholder word," artist Sara Genn says, "for the plumbing of infinity. As artists, if we knew what it was, if we could measure it, there would be nothing left to make. Its existence is its only meaning." It's the deep mystery at the heart of life that draws us forward and invites our longing for the best that life has to offer, the "rapture of being alive," as Joseph Campbell expressed it. If we fully understood the depths of life, we wouldn't have anything to strive for or have reason to co-create art. As the author of Soulcraft, Bill Plotkin wrote, "Soul is the largest possible conversation we can have with the world." Our soul inspires our hopes and dreams. It is that unquantifiable energy that seeks us even as we seek it. Let's embrace with vigor the journey

ART AND SOUL: Co-Creation and Sustainability

toward sustainability one day at a time to co-create what our best vision and desire inspire in us! Love, not fear, is the last word!

Whether online or in person, what groups have you found to help explore the deeper questions of sustainability?

What has helped you realize the interconnectedness of all things? What has prevented its realization?

What community leader or politician can you speak with about your concerns regarding sustainability?

What art form or co-creative activity will help sustain you in the days ahead?

Bibliography

Berry, Thomas. *The Great Work: Our Way to the Future.* New York: Bell Tower 1999

Fox, Matthew. *Creativity: Where the Divine and Human Meet.* New York: Jeremy P. Tarcher 2002

Hollis, James. *Finding Meaning in the Second Half of Life: How to Finally Really Grow Up.* New York: Jeremy P. Tarcher 2006

Moore, Thomas. *Care of the Soul: A Guide for Cultivating Depth and Sacredness in Everyday Life.* New York: HarperPerrenial 1994

Newport, Cal. *Digital Minimalism: Choosing a Focused Life in a Noisy World.* New York: Penguin LCC 2019

Odell, Jenny. *How To Do Nothing: Resisting the Attention Economy.* Brooklyn: Melville House Publishing 2019

Plotkin, Bill. *Wild Mind: A Field Guide to the Human Psyche.* Novato, CA: New World Library 2013

Swimme, Brian. *The Universe is a Green Dragon: A Cosmic Creation Story.* Rochester: Bear and Company 2001

Made in United States
Orlando, FL
04 April 2024